			(Septe
100			S BA A

					Do-
		Carlo La			
			Part de	LINE PA	
4					
			n'entre		
				La Reine	
	- book			100	
	Market Control				
		Miles			
				A Charles	
	Make Sales			OF AN LINE	the Roll of

Made in the USA Monee, IL 09 March 2023